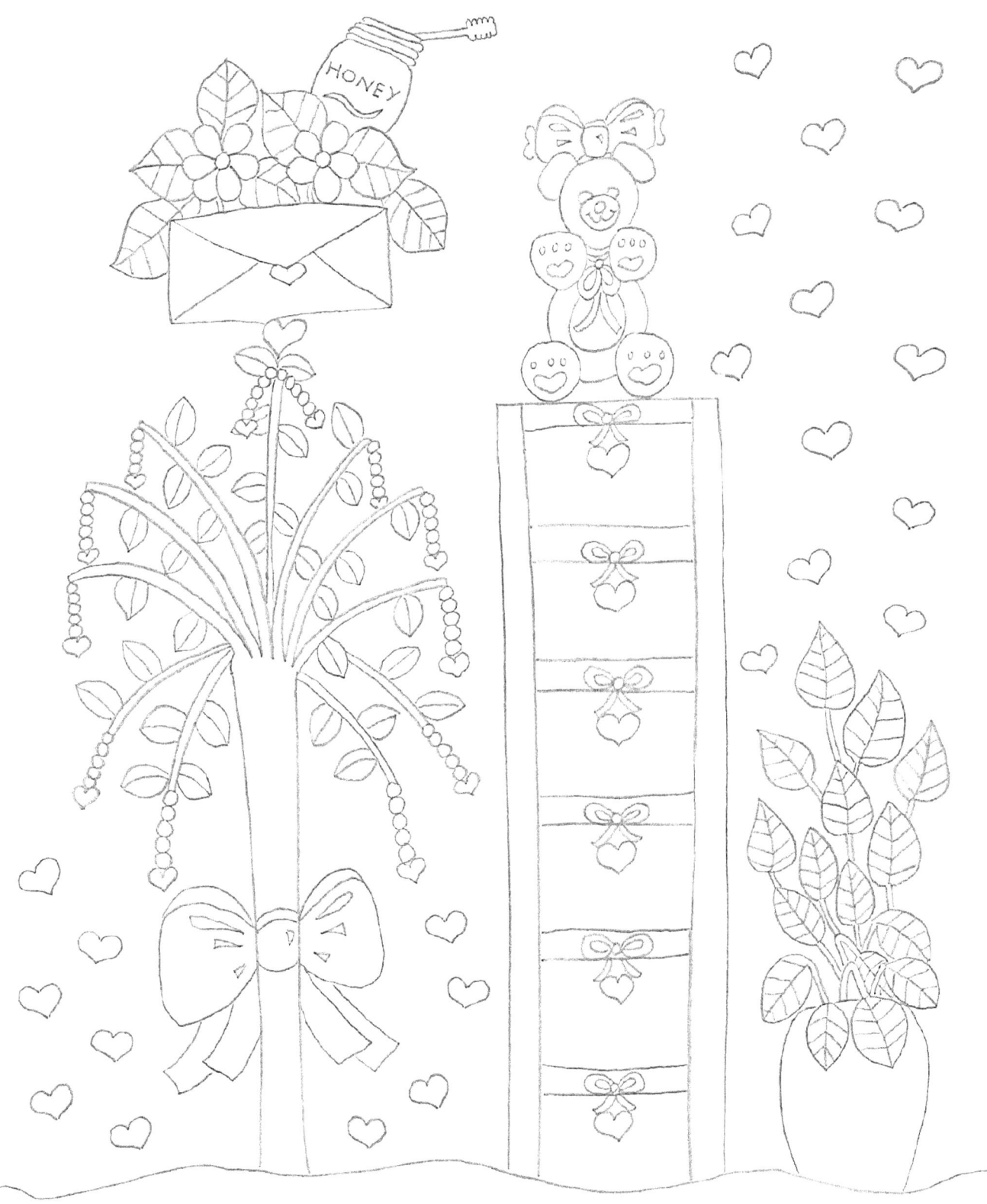

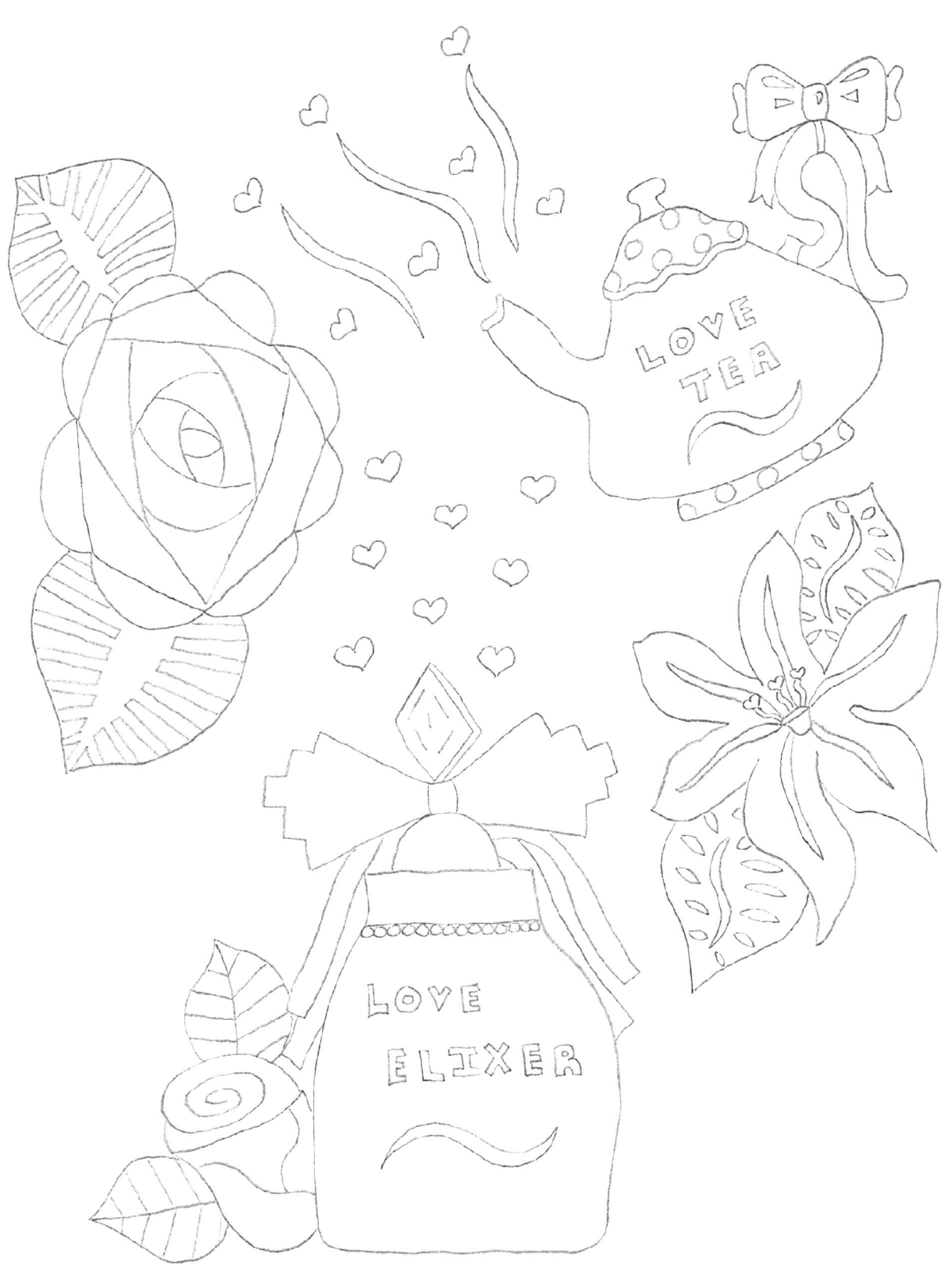

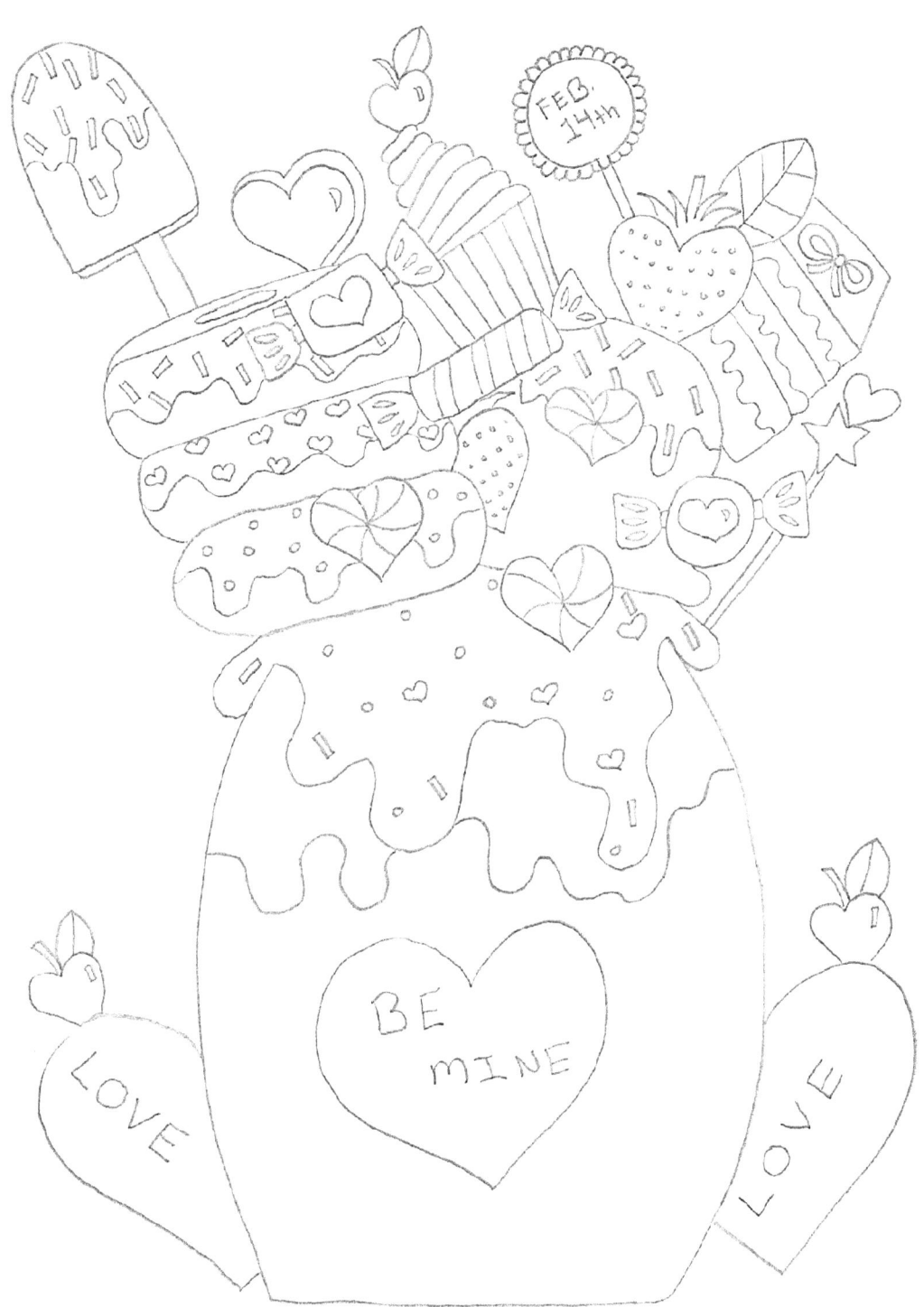

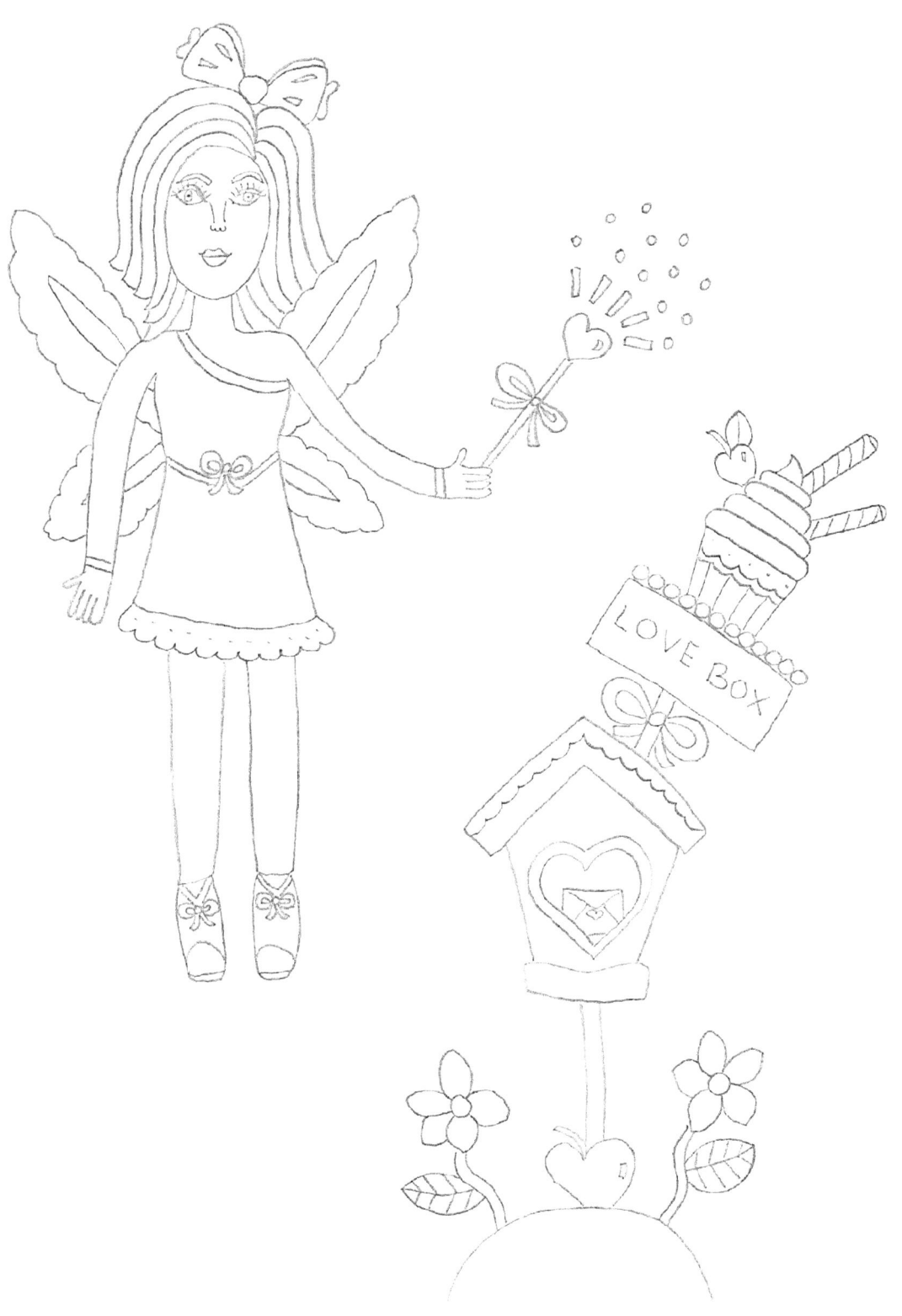

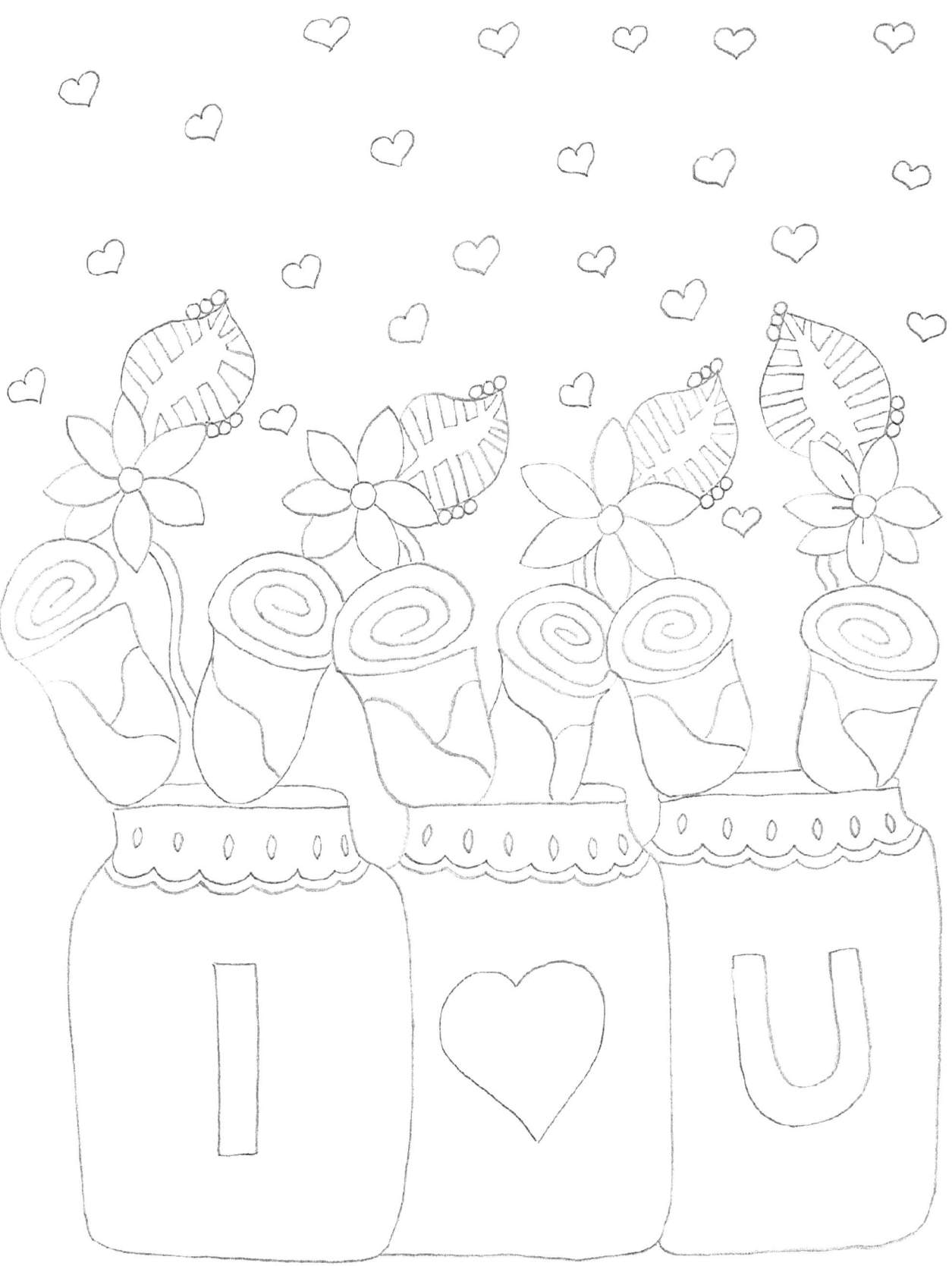

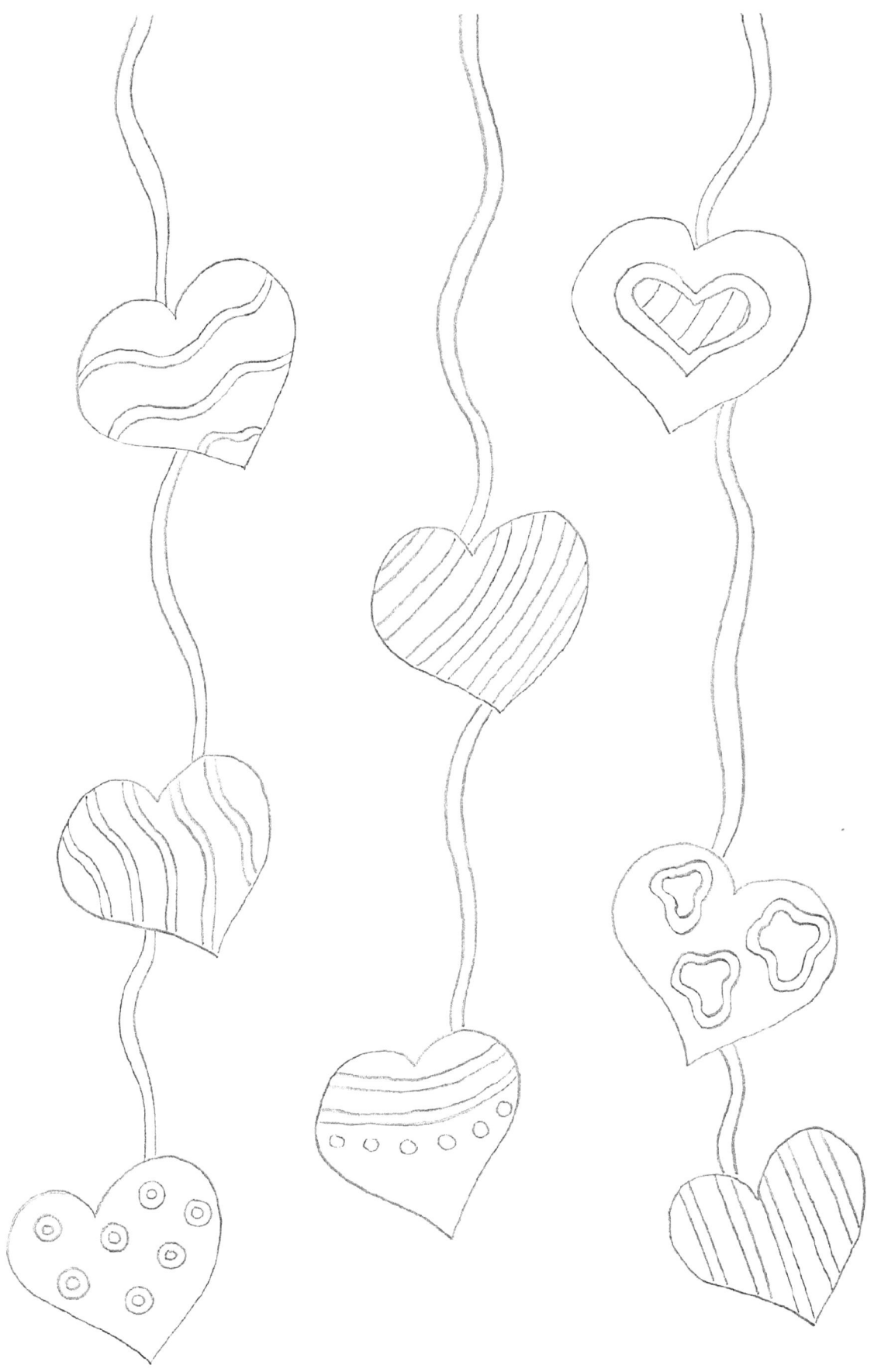

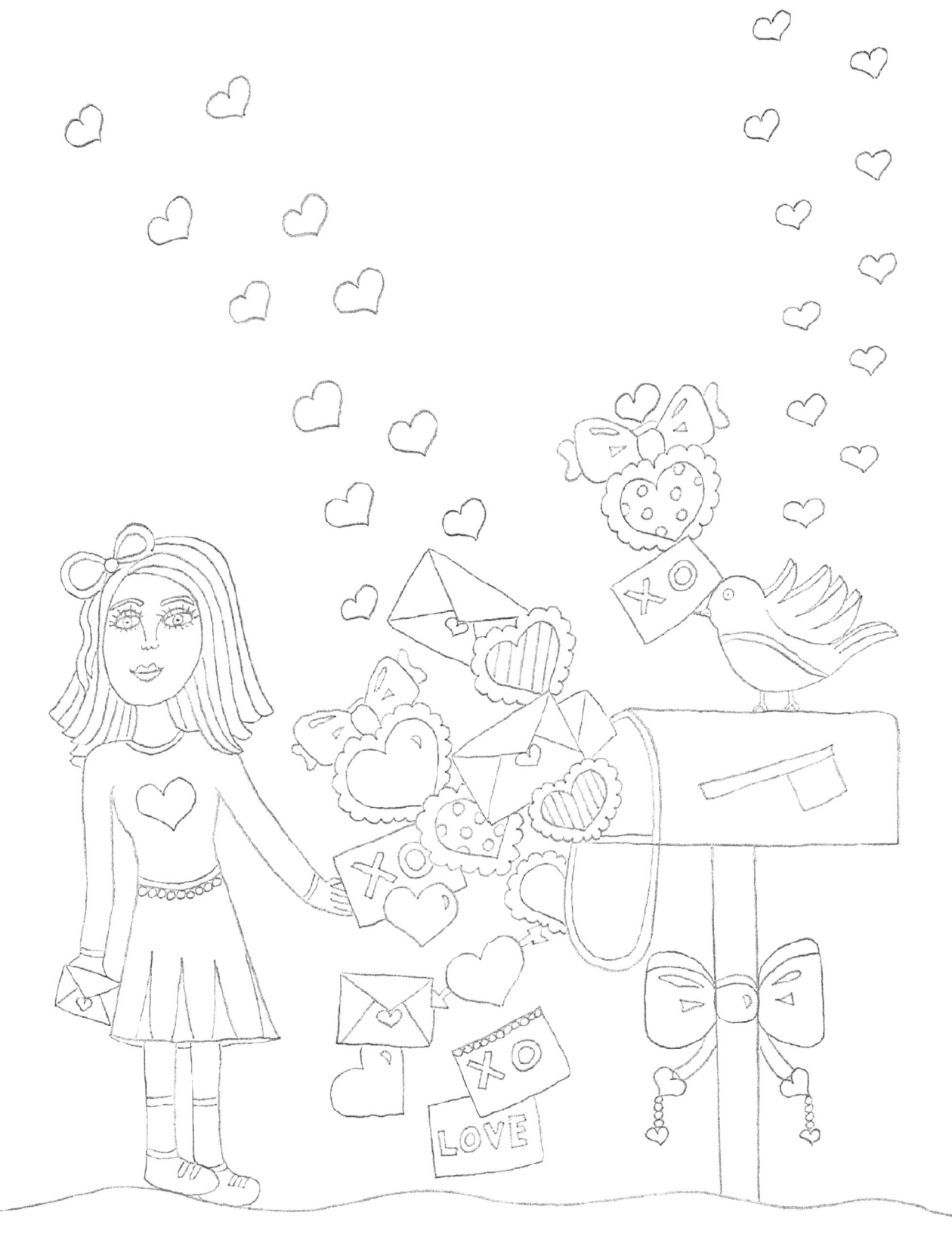

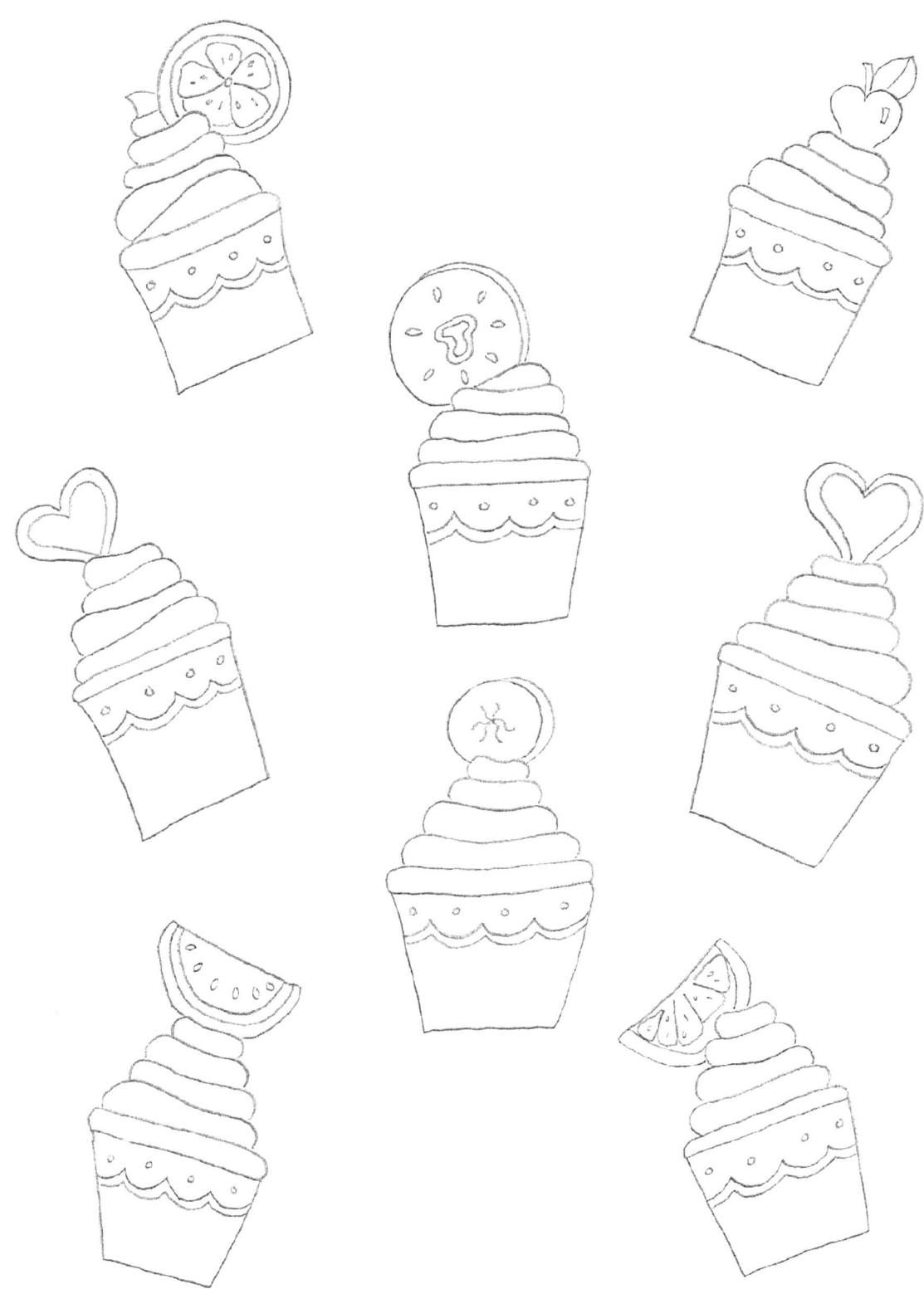

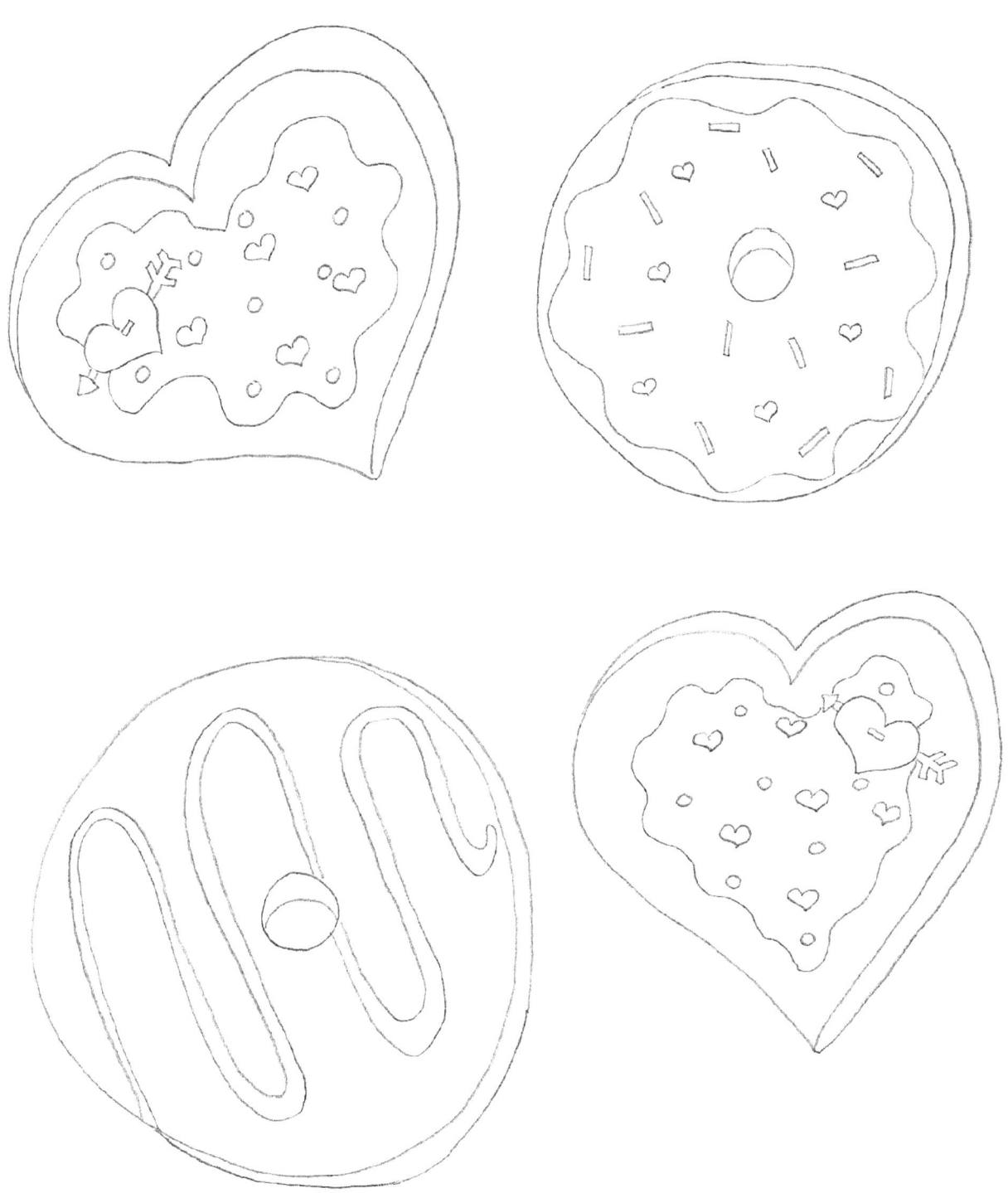

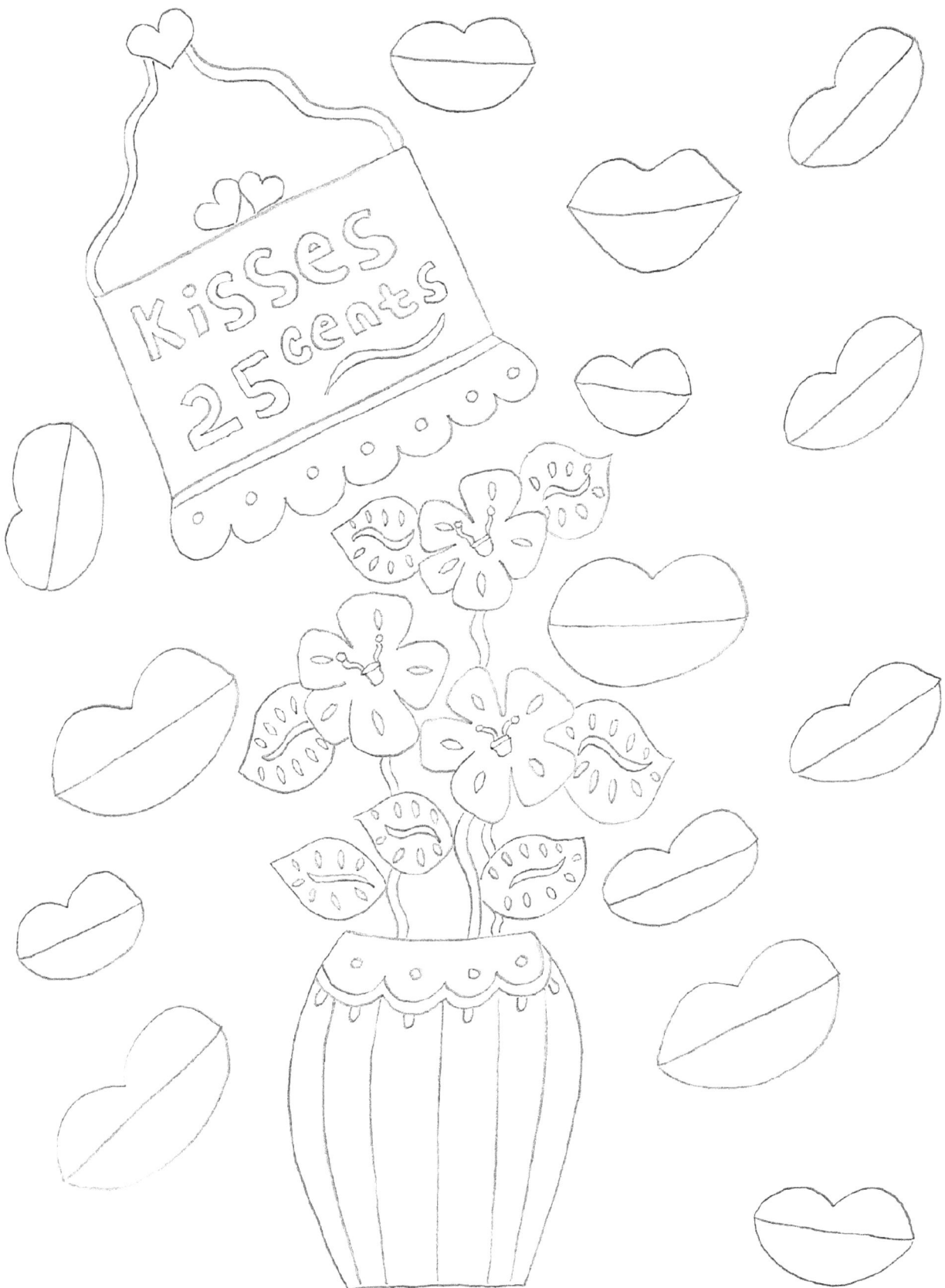

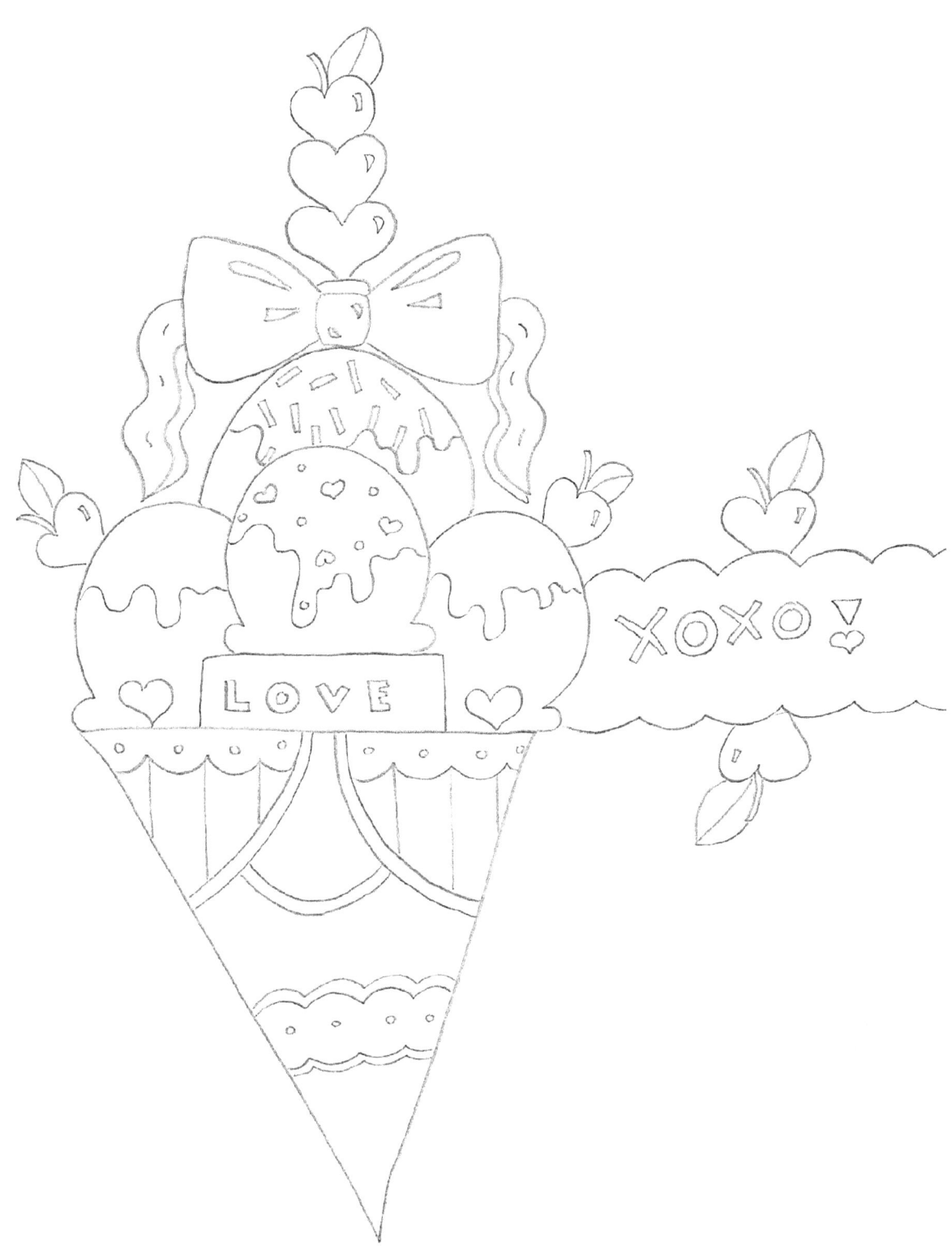

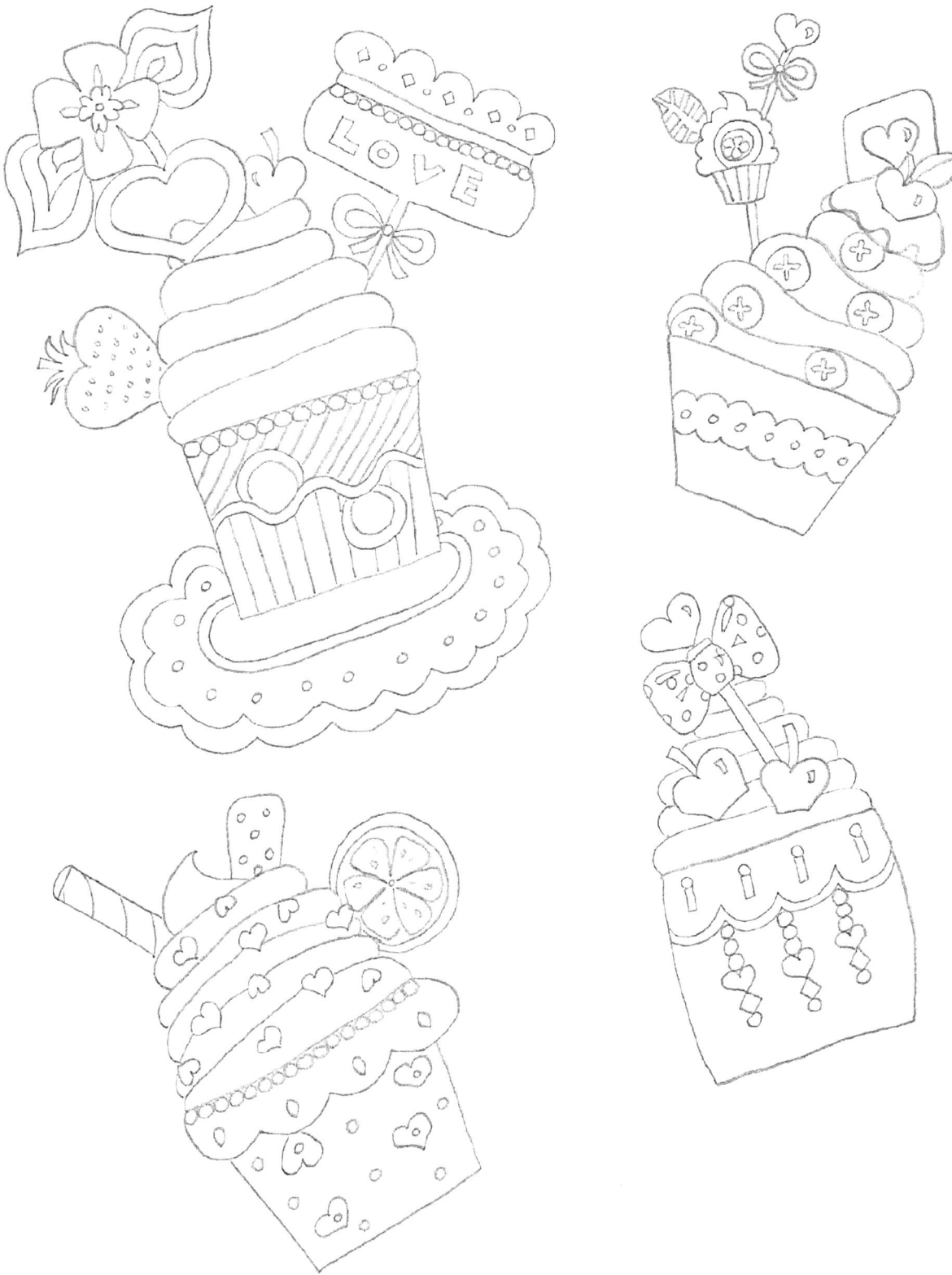

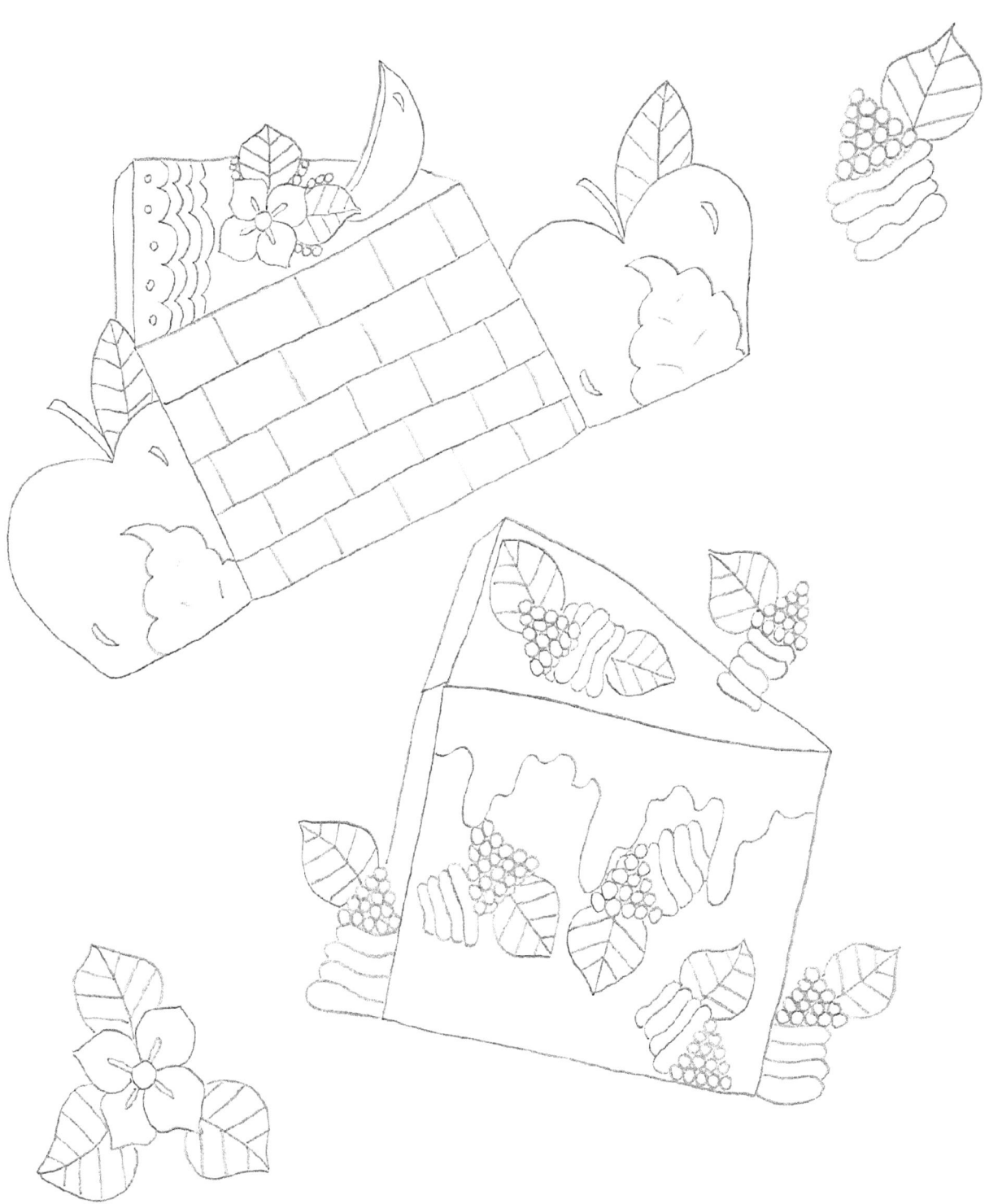

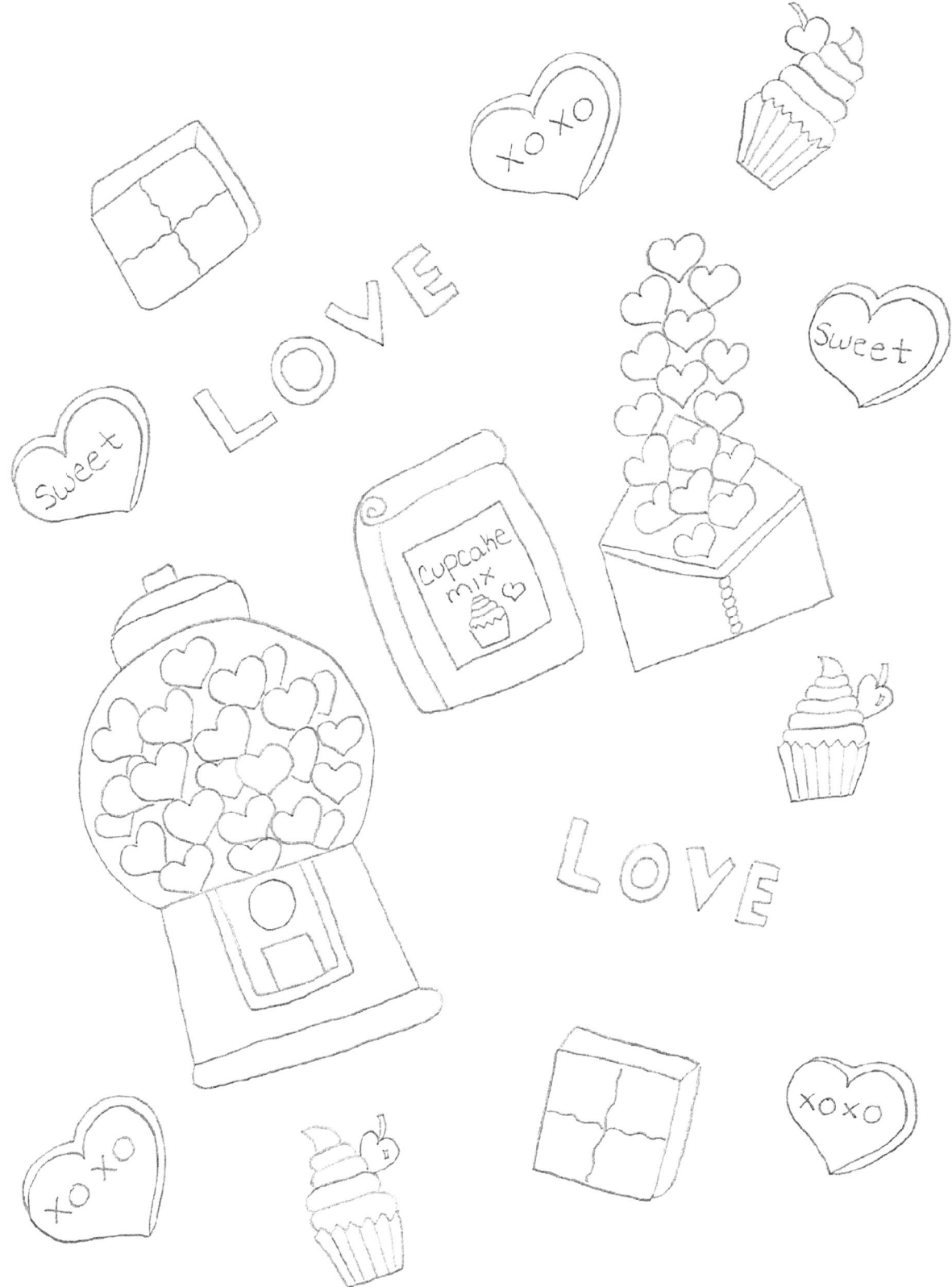

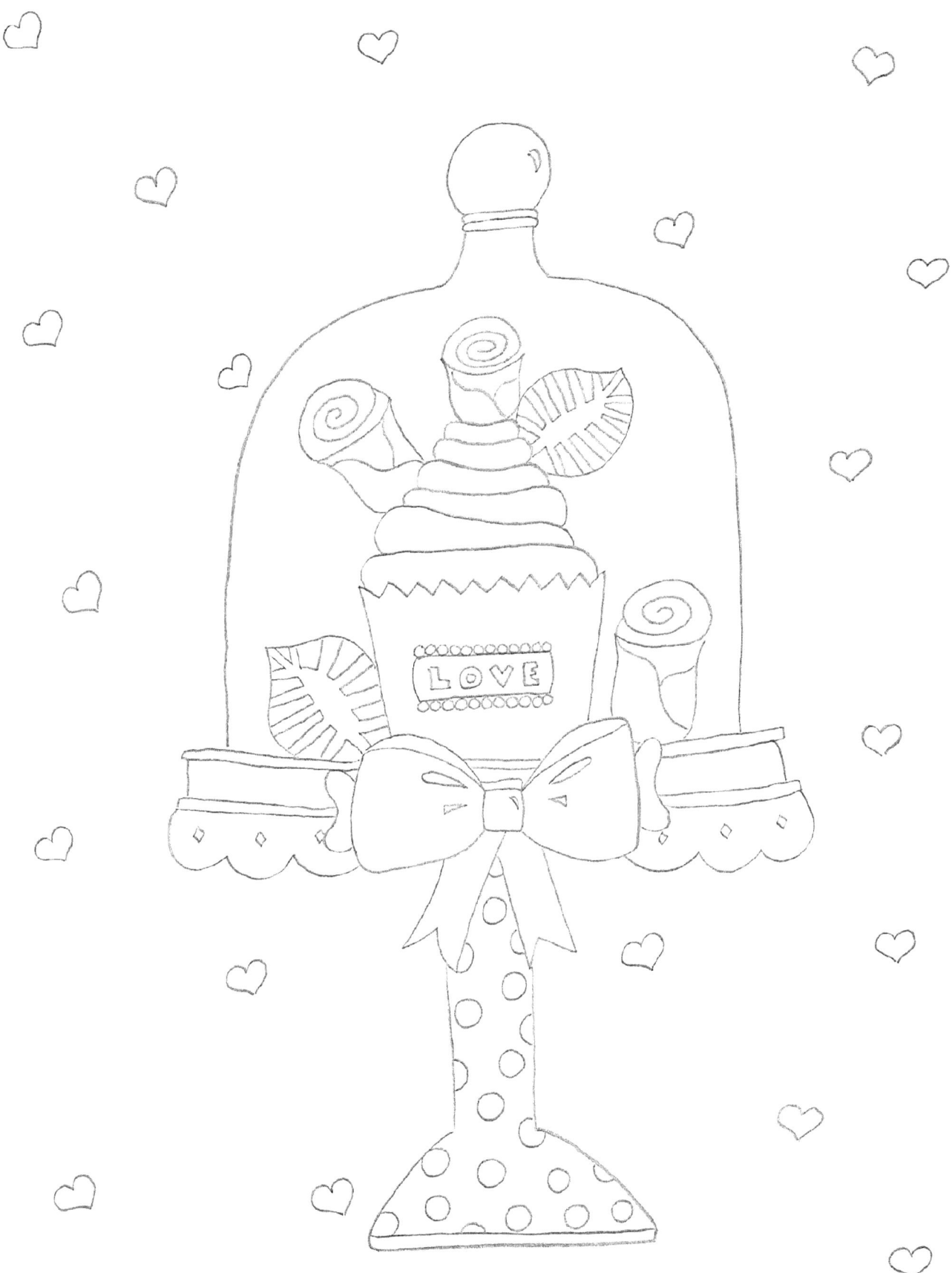

THANK YOU FOR PURCHASING VALENTINE'S DAYDREAMS COLORING BOOK. YOU CAN CHECK OUT MY OTHER COLORING BOOKS LISTED BELOW WHICH CAN BE PURCHASED AT AMAZON.COM:

VINTAGE PARIS BAKE SHOP (Adult)

VINTAGE WINE GARDEN (Adult)

ICE CREAM MADNESS (Adult)

ICE CREAM MADNESS VOLUME 2 (Adult)

TEA & COFFEE TROPICAL TREASURES (Adult)

TEA & COFFEE OCEAN TREASURES (Adult)

TEA & COFFEE TREASURES (Adult)

BOTANICAL FLOWERS & MANDALAS (Adult)

MAJESTIC FALL (Adult)

A VERY RETRO CHRISTMAS (Adult)

MAGICAL DESSERTS (Children)

MAGICAL DESSERTS VOLUME 2 (Children)

MAGICAL DESSERTS VOLUME 3 (Children

FASHION DOLLS (Adult)

FAIRIES IN THE FLOWER GARDEN (Adult)

MERMAID'S WONDERLAND SEA OF ENCHANTMENT (Adult)

CHRISTMAS DESSERTS

IF YOU ENJOYED YOUR COLORING EXPERIENCE, PLEASE TELL OTHERS ABOUT IT BY WRITING A REVIEW ON AMAZON.COM UNDER THE BOOK YOU COLORED.

www.ingramcontent.com/pod-product-compliance
Lightning Source LLC
Chambersburg PA
CBHW081638220526
45468CB00009B/2489